The
Creative Visualization
Workbook

by Shakti Gawain

Whatever Publishing, Inc.
San Rafael, California

© 1982 Shakti Gawain

Published by Whatever Publishing, Inc.
58 Paul Drive, San Rafael, CA 94903

88 89 90 13 12 11 10 9

Cover by Kathleen Vande Kieft
Back cover photo by Russ Fischella

ISBN 0-931432-12-X

Contents

How To Use Your Creative Visualization Workbook

This workbook is designed to be used along with my book, *Creative Visualization*. If you haven't read *Creative Visualization*, I suggest that you read it first. If you don't have access to a copy of it, or don't feel like reading it, you can probably still use this workbook very easily and successfully. But if you start feeling like you need more background or understanding of the principles on which these techniques are based, please do refer back to the book. There is also a *Creative Visualization* cassette tape on which I lead you through many of the techniques, meditations, and affirmations from the book.

The purpose of the *Creative Visualization Workbook* is to give you plenty of examples and an easy opportunity to practice some simple, effective techniques. Once you have been using it for awhile and have run out of space in the workbook, you can make your own workbook by getting a notebook or binder and making sections that correspond to the sections in this book. (Or by that time you may have discovered your own way of doing it.)

Using your *Creative Visualization Workbook* is meant to be fun, so don't take it too seriously. Play with it! If it stops being fun or interesting to you, put it aside for awhile and do what *is* fun and interesting to you. Come back to it when you feel the energy for it.

The first section of the workbook introduces you to a few basic techniques of creative visualization and gives you a chance to practice them.

Section Two is for learning to set goals in a way that is fun and enlightening, and can help you get more clarity and focus in your life.

Section Three will help you start getting in touch with and clearing out negative thoughts and belief systems.

In the fourth section, space is provided for you to do some of the basic techniques for each individual area of your life.

Section Five contains some special techniques to help you connect more with your intuition and creativity, and to generate positive energy.

Just for fun, I've enclosed a workbook record page at the end where, if you choose, you can make a note and give yourself a gold star every time you do some work in your workbook!

Supplies that you will need are:
1. Pens and/or pencils that you enjoy writing with. Sometimes people like to keep one special pen that they always use to write in this workbook — a sort of "magic pen."
2. Colored pens, pencils, or crayons that you like to draw with, for doing treasure maps. Or you might want to use watercolors and brushes.
3. If you want to do your treasure maps in collage form, you may want a bunch of magazines to cut pictures and words from.
4. A package of gold stars. Optional, of course!

Section One

Basic Techniques of Creative Visualization

The Basic Techniques and How To Use Them

The fundamental process of creative visualization is simply this — to imagine as clearly and realistically as possible *what you want to happen,* as if it has *already happened* or *is already happening,* thus creating an *inner experience* of what it would be like to have your desire come true. This process is really so simple that you can do it at any moment, just by closing your eyes (or leaving them open, if you prefer) and imagining your desired goal as if it were already true. No techniques at all are required to do this, and ultimately you can incorporate creative visualization as part of your natural way of thinking and living, moment by moment.

To help you get to the point where it is a natural habit to think creatively and use your imagination positively, there are many different specific techniques that you can practice.

In this section I will give you a few of the simplest and most effective exercises that I have used, and give you some guidelines about how to use them.

Here is the most basic creative visualization technique, in four steps:

1. Pick a goal — something that you desire to be, do, or have. Example: I would like to be more assertive.
2. Make an affirmation out of it. State it in a simple sentence, in the present tense, as if it were already true. Example: "I am an assertive person."
3. Picture it or feel it as if it were already true. Usually it's helpful to close your eyes and just pretend or imagine what it would be like if that were true. Don't worry if you can't picture it clearly, just feel it or imagine it in whatever way is easy for you.
4. Consciously turn it over to your higher self, or to the higher power of the universe, and let go of it. This means you don't try to *make* it happen, you relax and *let* the higher force go to work within you to create it. Then you go about your life, but be sure to follow your intuitive impulses and promptings, and be open to growing and changing.

Now here are four of my favorite creative visualization techniques which you can do easily and use regularly, if you want to. The first one is a meditation process, the next two are writing processes, and the fourth is an art process.

Pink Bubble Technique

This process combines the above four steps in a very simple, effective way.

Sit or lie down comfortably, close your eyes and breathe deeply, slowly, and naturally. Gradually relax deeper and deeper.

Imagine something that you would like to manifest. Imagine that it has already happened. Picture it as clearly as possible in your mind, or just feel or sense it.

Now in your mind's eye surround your fantasy with a pink bubble; put your goal inside the bubble. Pink is the color associated with the heart, and if this color vibration surrounds whatever you visualize, it will bring to you only that which is in perfect affinity with your being.

Now let go of the bubble and imagine it floating off into the universe, still containing your vision. This symbolizes that you are emotionally "letting go" of it, turning it over to the higher power of the universe to bring it to you.

You can do this process one time and let go of it completely, or you can do it regularly for awhile. If you want to do it regularly, I recommend every morning when you wake up, and at night before going to sleep.

Writing Affirmations

Take any affirmation you want to work with and write it 10 or 20 times in succession on a piece of paper. Use your name, and try writing it in the first, second, and third persons.

For example:

I, Shakti, have now finished the Creative Visualization Workbook.

Shakti, you have now finished the Creative Visualization Workbook.

Shakti has now finished the Creative Visualization Workbook.

Don't just write it by rote; really think about the meaning of the words as you are writing them. Notice whether you feel any resistance, doubts, or negative thoughts about what you are writing. Whenever you do (even a slight one) turn the paper over, and on the back write out the negative thought, the reason why the affirmation can't be true, can't work, or whatever. For example:

"I'm really not good enough" . . . *"I'm too old"* . . . *"This isn't going to work."*

Then go back to writing the affirmation.

When you are finished, take a look at the back of the paper. If you have been honest, you will have a good look at the reasons why you keep yourself from having what you want in this particular case.

With this in mind, think of some affirmations you can do to help you counteract these negative fears or beliefs, and begin to write out these new affirmations. Or you may want to stick with the original affirmation if it seems effective, or modify it slightly to be more accurate.

Keep working with writing the affirmations once or twice a day for a few days. Once you feel that you've really looked at your negative programming, discontinue writing it out, and just keep writing the affirmations.

Ideal Scene

Think of a goal that is important to you. It can be a long range or short range one. Write down the goal as clearly as possible in one sentence.

Underneath that, write *Ideal Scene,* and proceed to describe the situation exactly as you would like it to be when your goal is fully realized. Describe it in the present tense, as if it already exists, in as much detail as you wish.

When you have finished, write at the bottom:

"This or something better is now manifesting for me in totally satisfying and harmonious ways."

Then add any other affirmations you wish, and sign your name.

Then sit quietly, relax, visualize your ideal scene at your meditational level of mind, and do your affirmations.

Keep your ideal scene in your notebook, in your desk, near your bed, or hang it on your wall. Read it often, and make appropriate changes when necessary. Bring it to mind during your meditation periods.

One word of "warning": if you put it away in a drawer and forget about it, you are very likely to find one day that it has manifested anyhow . . . without your consciously putting any energy into it at all.

Treasure Map

Making a "treasure map" is a very powerful technique, and fun to do.

A treasure map is an actual, physical picture of your desired reality. It is valuable because it forms an especially clear, sharp image which can then attract and focus energy into your goal. It works along the same lines as a blueprint for a building.

You can make a treasure map by drawing or painting it, or by making a collage using pictures and words cut from magazines, books, or cards, photographs, lettering, and so on. Don't worry if you're not artistically accomplished. Simple, childlike treasure maps are just as effective as great works of art!

Basically the treasure map should show you in your ideal scene, with your goal fully realized.

Here are some guidelines that will help you make the most effective treasure maps:

1. Do a treasure map for a single goal or area of your life, so that you can be sure to include all the elements without getting too complicated. This enables the mind to focus on it more clearly and easily than if you include all your goals on one treasure map. You might want to do one treasure map for your relationships, one for your job, one for your spiritual growth, and so on.
2. You can make it any size that's convenient for you. You may want to keep it in your notebook, hang it on your wall, or carry it in your pocket or purse. I usually make mine on light cardboard which holds up better than paper.

3. Be sure to put yourself in the picture. For a very realistic effect, use a photograph of yourself. Otherwise draw yourself in. Show yourself being, doing, or having your desired objective — traveling around the world, wearing your new clothes, proud author of your new book, opening up to your higher self, etc.
4. Show the situation in its ideal, complete form, as if it already exists. You don't need to indicate how it's going to come out. This is the finished product. Don't show anything negative or undesirable.
5. Use lots of color in your treasure map to increase the power and impact on your consciousness.
6. Show yourself in a real setting; make it look believable to yourself.
7. Include some symbol of the infinite which has meaning and power for you. It could be an "om" sign, a cross, Christ, a Buddha, a sun radiating light or anything that represents universal intelligence or God. This is an acknowledgement and a reminder that everything comes from the infinite source.
8. Put affirmations on your treasure map. *"Here I am driving my new Datsun truck with a camper top. I love it, and I have plenty of money to maintain it."*

Be sure to include also the cosmic affirmation *"This or something better now manifests for me in totally satisfying and harmonious ways for the highest good of all concerned."*

The process of creating your treasure map is a powerful step toward manifesting your goal. Now just spend a few minutes each day quietly looking at it, and every once in a while throughout the day give it a thought. That is all that's necessary.

Practice With The Basic Techniques

Now I will guide you through using these techniques with a goal of your own, so that you can practice using them.

First pick a goal. It can be on any level — material (i.e. a house, a car, a job, etc.), emotional, or spiritual.

For this first one, pick something that is important to you, that's fairly realistic and believable, and that you feel pretty positive about. Write it down here in a simple, specific sentence:

My goal is to _____

Now make an affirmation out of it by writing it in a sentence in the *present* tense, as if it were *already* true. (Make sure you don't use words like "I *will* have", or "I *want* to do" — that puts it in the *future,* not the present. Use phrases like "I *now* have", "I am *now* doing", etc.) Keep it as short and simple as possible. For more examples of affirmations, please refer to *Creative Visualization.*

My affirmation: _____

Now close your eyes, take a few deep breaths, and relax your mind and body. Say your affirmation to yourself a few times and imagine that it is true. "Try it on for size" and see how it feels to have your desire come true. Then imagine you put it in a pink bubble, toss the bubble into the air, and let go of it.

Now consciously affirm "I am turning this over to the higher intelligence of the universe within me, to guide me in creating it."

You can also repeat the "cosmic affirmation":

This or something better is now manifesting for me in totally satisfying and harmonious ways, for the highest good of all concerned. So be it. So it is.

Okay, now try writing an ideal scene for this particular goal. Write a few paragraphs describing in as much detail as possible this goal as if it were *already* true (in the present tense). See p.11 for instructions.

If you have any trouble doing this, see if you can project yourself into the future, to the time when this goal has been fully created. Then pretend you are writing a letter to your best friend, describing the situation in detail.

So for example, if your goal is to create a job you like, then you would write a description of your ideal job as if you were already there, describing where you work, what you are doing, your surroundings, co-workers, how much you are getting paid, etc.

After you have written your ideal scene, use the next page to try drawing a treasure map. (See p.11 for instructions.) Remember not to be concerned about your artistic ability, or lack of it. This is for fun! And it's also very effective. Feel free to turn the page horizontally if your picture will fit better that way.

On the last page in this section practice writing your affirmation, with the clearing process, as described on p.10. You may find as you go along that your affirmation changes somewhat. Or perhaps you will get in touch with another affirmation that seems better, more accurate, or more important to you. Always be flexible and open to changes.

How To Proceed With Creative Visualization

Once you have done each of the exercises, you can continue to work on creatively visualizing this goal, if you choose, by doing the pink bubble technique and saying your affirmations in meditation every morning and night, and by doing the writing affirmation (with clearing) process every day or a couple of times a week for awhile.

If you have other goals that you want to work on, you can go through the same process with each of them. When you are starting to learn creative visualization, it is usually a good idea to focus on one or two things at a time for the sake of simplicity. Later you may find that you can focus on more things at once, or you may want to keep it simple.

Keep visualizing and playing with a particular goal as long as you have energy for it and it feels good to do so. If you start feeling bored with it, or discouraged, it may be time to let it go for awhile. Often when you let something go and forget it for awhile, you will later realize that it has manifested in your life while you weren't looking, so to speak!

There really are no rules about how to use creative visualization. Each person is different, and each situation is different. I can make suggestions based on my experience, but the ultimate authority for you is you. You must experiment to find out what feels good to you, and what works effectively for you, and that will probably change from time to time. Trust your own intuition, and do what feels right for you.

Sometimes people get frustrated and annoyed with themselves because they don't use the techniques regularly, even though they've found that they work. Don't use creative visualization as another reason to get down on yourself! Trust yourself. If you don't feel the energy to do this work regularly, there may be a reason that only your inner self knows about as yet.

My philosophy is this: *If you feel like doing it and have a sense that you need to make a regular practice of this for awhile, then do it. You will find it very rewarding. If you don't, don't worry about it. The most important thing is that you've got the understanding that you are responsible for creating your life. If you can remember, moment by moment as you live your life, to be more aware of your thoughts and beliefs, and how you are creating your reality, you will be doing a lot. Then when you feel especially motivated by a particular desire or problem, go ahead and use the appropriate creative visualization techniques to work on it.*

In the following sections, we will explore more deeply into some particular aspects of the creative visualization process.

Section Two

Goals

How To Create Goals and Enjoy It

Every time you have a desire, in a certain sense you have a goal — something that you would like to be, do, or have. Some desires are merely passing fancies, but others stay with us and go deeper. Our desires and goals give us direction and focus, they help to point us down our path of action in life.

For many people, the word "goal" has a negative connotation because it has so often been associated with compulsiveness, pushing, driving ourselves, competing with others, and so on. And truly, goals are often very much misused. But you can't really get away from having goals anyway (even if your goal were just to have no goals, or to just be in the moment, or to meditate all day, that's still a goal!). So you might as well learn to use and enjoy them.

To enjoy your goals, think of them as signposts pointing you in a certain direction. They give you a certain focus and help your energy to get moving. The *way* you go is up to you; you can get very uptight getting there, focusing only on getting to your goal, or you can relax and enjoy the journey, appreciating every step of the way, every unexpected bend and turn of the road, every new opportunity for learning something.

So go ahead and play with setting goals when and if you want to. See how it feels to you and whether it helps you or not. If you are already a very organized, goal-oriented person and you tend to use goals to control your life and stifle your spontaneity, it would be better to make your only goal be to relax and act spontaneously for awhile. But if you tend to be disorganized, or have a hard time getting into action, setting goals may really help you. It's a very individual thing.

Here are some guidelines:

1. With short range goals, be realistic. Don't set them too high, or you'll end up feeling discouraged. It's better to take a short, reachable step and then set a new goal, to create a feeling of confidence.

2. With long range goals, be expansive and idealistic. Let your imagination open up and reach for the highest. This will inspire you.

3. Put your main focus on the *essence* of the goal. Don't worry about the details, those may change.

4. Don't be compulsive about your goals. Don't try to *make* them happen. Hold them lightly, relax, and *let* them happen at their own pace and in their own way. Turn them over to your higher self to create them, and *let go*.

5. Be flexible. You will probably find that many of your goals change frequently, but there is an essence in the most important ones that remains the same, and helps to guide you closer to your highest purposes.

Goals Process

This is a goals process that is useful to do at least once. You may want to repeat it every six months or once a year perhaps, just to see how things change for you. Its purpose is to open up and expand your imagination, as well as to help you focus on what things are truly most important to you.

When I first did this process, I thought it would be impossible to know what my long range goals would be. ("How am I going to know what I'll want in five years?") But I started doing it anyway, just for fun, and I was amazed at how much came out of it for me. So just think of this as a learning/playing experience.

Instructions: Under each category write a list of three to ten goals that are the most important things you would like to accomplish or create by that time. Write each goal in the form of an affirmation — that is, write it in a sentence, in the *present* tense as if it had *already* come true. This will make it a powerful process of creative visualization. So instead of saying "I *want to* live in a bigger, sunnier, more beautiful apartment," you would phrase it this way: I *am now living* in a big, beautiful, sunny apartment that I love."

Example: My most important goals for the next month (i.e., the things I most want to have accomplished in a month's time) are:

1. *I have now easily and successfully completed the special project I've been working on for my boss.*
2. *I have paid off the last of my debt and opened a savings account.*
3. *I am now taking a walk and spending a little time outdoors everyday.*
4. *I am getting more in touch with my feelings and learning to express myself better.*
5. *I have now taken my first guitar lesson.*
6. *The closet in my bedroom is neat and orderly!*

When you write your short range goals (one month, two months, six months) try to be realistic, choose goals that you can *fairly* easily accomplish. If you set your standards too high, you may feel discouraged in a month or two if everything doesn't happen. With longer range goals (especially five years, ten years, lifetime), allow yourself to be as fantastic and idealistic as possible.

My most important goals for the next month are:

My most important goals for the next six months are:

My most important goals for the next year are:

My most important goals for the next two years are:

My most important goals for the next five years:
(What I would like to have created in five years)

My most important goals for the next ten years are:
(What I would like to have created in ten years)

My most important goals for my life are:

Current Goals

This is a process you can do on a regular basis, say once a month, or anytime you just want to take a look at what's most important to you at the time, and where your highest priorities are.

Just list the five or six most important goals in your life at the current time — that is, things that you would like to be putting your energy into right now or in the near future. Some of them may be short term goals, some may be long term, but they are the ones you feel most strongly about at the moment.

The most important current goals in my life are:

Section Three

Clearing

What Is Clearing?

The creative power of the universe is always trying to move through us, to create through us. The clearer and more aligned with our higher selves we are, the more easily that creative energy can move through to help us manifest our hearts' desires. But that creative power has to filter through our beliefs, attitudes, emotions, and habits. The more negative and constricted our beliefs and patterns are, the more they block, slow, and distort the creative energy.

So one of the most important aspects of using creative visualization is the clearing process — letting go of false, constricting beliefs and patterns, and replacing them with positive, supportive ones.

Clearing has to ultimately take place on all levels — physical, emotional, mental, and spiritual. There are many methods of clearing, including many forms of psychotherapy, bodywork and massage, yoga, various forms of exercise and breathing, rebirthing, psychic energy work and healing, and so on. I have used many of these methods myself and found them powerful and important in my process. I recommend that you follow your own intuitive feelings about what kinds of clearing processes you may need at any given time.

The underlying principle in most forms of clearing is that you must recognize and be willing to fully acknowledge and experience any repressed negativity in your body, emotions, mind and spirit, in order to fully release it. Most people hope that by ignoring negativity, it will go away, but the reverse is actually true. The harder you try to ignore it, the more it tends to come up in your life. It's as if all the dark places inside of you are actually trying to pull the light of consciousness to them, so they can get cleaned out. The cleaning process happens through simply shining that light of awareness into the dark places and being willing to experience what is there. Through experiencing it, the blocked energy is released forever, and you are free to replace it with positive beliefs and attitudes.

So the more willing you are to face, own and consciously experience your negative beliefs and patterns without judging yourself for them, the quicker they will get cleared out.

The following are some simple clearing processes that you can do by yourself.

Basic Clearing Process

This is the most basic clearing process that you can use anytime you have a goal or desire that you feel may be blocked.

First, state your goal in the form of an affirmation.

Second, write "The reasons I can't have what I want are" and then start listing every thought that comes into your head, no matter how silly, weird, terrible, or insignificant it seems. List as many reasons as you can possibly think of.

Example:

Goal: I now have a wonderful, creative job that I love and that pays me $2,000 a month or more.

The reasons I can't have what I want are:

> *I'll never be a success*
> *I don't know what I want to do*
> *Where will I ever find a job like that, that's too good to be true*
> *I don't deserve it*
> *I'm afraid to make that much money*
> *My father never made that much, I don't want to make him look bad*
> *Etc.*

Third, once you have written all the reasons you can possibly think of (you may want to leave it and come back several times with more thoughts), then sit for awhile and look at your list. Decide which of the negative statements have the most power over you, and make a mark by those. Then write an affirmation to counteract each one. Take the affirmations that feel most powerful to you, and meditate on them every day for awhile, along with your original goal/affirmation.

Affirmations:

My higher self is now guiding me to my perfect job. I deserve to be successful and make money! My father supports me in being successful.

On the next page, practice the basic clearing process with a goal of your own. Pick one that you have some resistance, fears, or doubts about being able to create.

Goal:

The reasons I can't have what I want are:

Affirmations:

Forgiving and releasing others

Write down the names of everyone in your life whom you feel has ever mistreated you, harmed you, done you an injustice, or toward whom you feel or have felt resentment, hurt or anger. Next to each person's name write down what they did to you, or what you resent them for.

Then close your eyes, relax, and one by one visualize or imagine each person. Hold a little conversation with each one, and explain to him or her that in the past you have felt anger or hurt toward them, but that now you are going to do your best to forgive them for everything, and to dissolve and release all constricted energy between you. Give them a blessing and say, *"I forgive you and release you. Go your own way and be happy."*

When you have finished this process, write across the paper *"I now forgive you and release you all."*

The people in my life who have hurt me are:
(Write their names and what they have done to you. Then do the exercise.)

When you finish this exercise you can tear this page out and throw it away, as a symbol of letting go, or just write "Forgiven and Released" in big letters across the page.

Forgiving and releasing yourself

Now write down everyone you can think of in your life whom you feel you have hurt or done an injustice, and write down what you did to them.

Again close your eyes, relax, and imagine each person in turn. Tell him or her what you did, and ask them to forgive you and give you their blessing. Then picture them doing so.

When you have finished the process, write at the bottom of your paper (or across the whole thing) *"I forgive myself and absolve myself of all guilt, here and now, and forever!"*

The people in my life whom I have hurt are:
(Write their names and what you feel you did, then do the exercise.)

When you finish this exercise you can tear this page out and throw it away, as a symbol of letting go, or just write "Forgiven and Released" in big letters across the page.

Core Negative Beliefs

When people learn that they create their own reality, and that by focusing their mind on positive images and thoughts, they can create a more positive reality, they sometimes become afraid of their negative thoughts. They fear that if they have a negative thought or idea, they are going to create that in their lives. Often people try to suppress or ignore their negative thoughts, and valiantly try to focus only on the positive. I believe that this is a mistake. Our negative thoughts are valuable messages to us about our deeper fears and negative attitudes. Negative thoughts that you are *consciously aware* of do not cause real problems. Once you are conscious of them, they are already on their way to being cleaned out. It's the negative beliefs that we hold on deep levels and are not even aware of that cause the negative experiences in our life, and prevent us from creating what we consciously want.

The real troublemakers are the "core negative beliefs" — the deepest and most fundamental assumptions and expectations we have about life, the world, ourselves and others. These are usually so basic to our thinking and feeling that we don't realize they are beliefs at all; we assume that they are simply the true nature of reality, just "the way life is." As long as we have these unrecognized deep-seated beliefs, they continue to govern the way we create our reality. So for example, you may be consciously affirming and visualizing prosperity, but if your unconscious belief is that you don't deserve it, or that it's immoral or unspiritual, then you won't create it.

So your negative thoughts and worries can be used positively if you are willing to be conscious of them and look deeper, to see what lies underneath them. Once you become *aware* of your core negative beliefs, you can change them.

There are an infinite number of core negative beliefs, and all of us have our own unique ones. But there are certain ones that are so prevalent in our culture that most of us have them in some degree. Here are six of the most basic that I have found (each has many variations and outgrowths). I have included some possible affirmations for each one.

1. *I am powerless.*
 I don't have the power to create my life. I'm a victim of outside circumstances. I'm helpless. Other people do things to me. I'm not responsible for what happens to me.
 Affirmations: I am a channel for the creative power of the universe. I am powerful. I am responsible for creating my life.

2. *Scarcity.*
 There's not enough to go around of whatever I want. Therefore I have to do without (or grab more than my share and cause others to do without, or grab it while I've got the chance).
 Some things we feel are scarce:
 > Money . . . Love . . . Time . . . Energy . . . Space . . . Good . . . Health . . . Youth . . . Vitality . . . Jobs . . . Pleasure . . . Sex . . . And so on . . .

Affirmations: The universe is the source of _____ and there is more than enough for all my needs. There is an abundance of _____ in my life. I always have everything I need.

3. *Life is a struggle.*
 Things are hard. Life is difficult. It's not okay for life to be easy, enjoyable, pleasurable, fun. If things are going well, watch out! Something bad is sure to happen. If I suffer enough in this life, I'll get my reward (hopefully) in the next.
 Affirmations: As I follow my inner guidance, life is a flow. Life is full and pleasurable. It's okay for me to relax and have fun.

4. *I'm an unworthy person.*
 I don't deserve to be happy, healthy, wealthy. I don't deserve to be loved. Something's wrong with me. I'm not good enough. I'm not smart, talented, lovable (or whatever).
 Affirmations: I love myself. I accept myself. I deserve to be happy (healthy, wealthy, etc.). I deserve to be loved.

5. *Fear of failure. Fear of fuccess. Fear of power.*
 I'm afraid to take a risk, for fear I'll fail or succeed. If I fail others will reject me. If I succeed others will envy me, want something from me. I'll be isolated. I won't be able to uphold my image. I'll be too powerful. I'm afraid of my own power.
 Affirmations: It's okay for me to risk being myself. I don't need others' validation. I validate myself. I trust my power. It's okay for me to be a success.

6. *I don't trust myself. I don't trust the universe.*
 I'm afraid to trust my feelings, my intuition. I'm afraid there is no higher power to take care of me. I'm afraid to go with the power of the universe inside of me. I'm afraid to let go of my individual control and surrender to the higher force.
 Affirmations: I trust myself. I trust the higher power inside me.

There are many other core beliefs as well, so be open to discovering your own.

Deeply recognizing a core negative belief in yourself is 99% of the process of letting go of it. It will probably take awhile to dissolve, but it will be on its way out, once you really see and feel how it has been operating in your life. You can help to dissolve it by using an affirmation. To find a good affirmation, first write down your negative belief as accurately as you can, in a sentence. Then write a positive statement that corrects and counteracts the negative one. For example:

Negative belief: I'm afraid of my power. I'm afraid I'll hurt someone.

Affirmation: I trust my power. It always causes me to act for the highest good.

The following exercise will help you get in touch with your negative belief in any given situation.

Core Belief Process

This process can be done best with a partner, but you can also do it alone. If done with a partner, one of you should ask the questions and the other answer them (take about two or three minutes for each question) all the way through to the end. Then switch and have the other person ask the questions, while their partner answers.

If you do it alone, you can write your answers to each question, or just answer them silently to yourself, or speak into a tape recorder and listen back.

Sit silently for a moment, eyes closed, and get in touch with that part of yourself that is powerful and responsible — the creator of your experience. Now think of a particular situation, problem, or area of your life where you need to expand your awareness or become more conscious.

Now answer the following questions:

1. Describe the problem, situation or area of your life that you want to work on. Take three or four minutes to talk about it generally.
2. What emotions are you feeling? (Describe the *emotion* — i.e., fear, sadness, anger, guilt. Do not describe the *thoughts* you are having about it.)
3. What physical sensations are you feeling?
4. What are you thinking about it? (What tapes or programming are running in your head? What negative thoughts, fears, worries are you having?) Take three or four minutes to describe.
5. What is the worst thing that could happen in this situation? (Your greatest fear.) Suppose that happened. Then what would be the worst thing that could happen? What if that happened? Then what would be the very worst thing that could happen?
6. What's the best that could happen? Describe the way you'd ideally like it to be, your ideal scene for this area of your life.
7. What fear or negative belief is keeping you from creating what you want in this situation? Once you have explored this question, write your negative belief in one sentence, as precisely as you can. If you have more than one, write each of them down.
8. Create an affirmation to counteract and correct the negative belief. Here are some guidelines:

 (a) The affirmation should be short, as simple as possible, and meaningful for you.
 (b) It should be in the *present* tense, as if it's already happening.
 (c) It should use your name.
 Example: "I, Shakti, am a worthy person. I deserve to be loved!"

45

(d) The affirmation should *directly* relate to your basic negative belief and turn it into a positive, expansive one.
Some examples:
Negative belief: "The world is a dangerous place. I have to struggle to survive."
Affirmation: "I, Shakti, now live in a safe, wonderful world. The more I relax and enjoy myself, the safer I am."
Negative belief: "Money corrupts people."
Affirmation: "The more money that flows into my life, the more power I have to do good for myself and others."

(e) Your affirmation should feel exactly right for you. (It may cause a strong emotional feeling.) If it's not right, try changing it until it is.

9. Then:

(a) Say your affirmation silently to yourself in meditation, picturing everything working out perfectly as you want it.

(b) If you have a partner, have your partner say your affirmation to you, using your name and looking deeply into your eyes. After he/she says it, you say "Yes, I know!" Repeat this process 10 or 12 times. Then *you* say your affirmation and your partner says "Yes it's true!"

(c) Write your affirmation 10 or 20 times a day. If negative thoughts arise, write them on the back of the paper, then keep writing the affirmation on the front until it feels clear.

Section Four

Specific Areas

Focusing On Specific Areas Of Your Life

In this section you have the opportunity to do some of the basic creative visualization techniques for each different area of your life.

I suggest that you not try to do all of them at once. Pick one or two aspects of your life that you feel are of prime importance to you at the moment and focus on those for awhile. Then come back later and do another one, and so on.

I have divided the areas into these categories:

My Relationship With My Self

My personal and spiritual development, my self-image, feelings about myself, qualities that I want to develop, my relationship with the higher power, etc.

My Relationship With Another

This one could focus on a particular relationship that I want to create or improve, or it could deal with my relationships in general.

Work, Creativity, Financial Prosperity

This one focuses on my primary work or creative expression. It could be something I'm currently doing and want to be more successful at, or developing a new expression. It also deals with improving my financial situation.

Home and Possessions

If I desire to change or improve my living space, or create a different one, I would use these pages. Or if I have a special possession or possessions I want to acquire. (Car, furniture, clothes, or whatever.)

Health and Appearance

If I have a goal to heal myself, to increase my physical fitness, lose or gain weight, take better care of my body, become more beautiful, or whatever, I'll use this category.

Recreation and/or Travel

This is for creating a special vacation or anything else for fun.

The World Around Me

It's fun and creative to take some time to visualize a more perfect, enlightened world. Use your imagination to transform things the way you'd like them to be.

Of course, your particular goals may not fit into these categories, so feel free to create your own!

In each of the categories, you will find a place to write one, two, or three current affirmations (goals) for that area of your life, a place to write an ideal scene, a clearing process, a page for a treasure map, and a page for writing your affirmation (with clearing on the back). Don't forget to also practice your pink bubble meditation.

Have fun!

My Relationship With My Self

My current goals in this area are:
(Write in the form of affirmations. Write one, two, or three affirmations.)

1.

2.

3.

My ideal scene for my relationship with myself:

The reasons I can't create the kind of relationship that I want with myself are:

(Feel free to tear this page out and throw it away once you feel you've gotten all possible negative feelings and thoughts written down.)

My Relationship With My Self
Treasure Map

Feel free to turn the page the other way if it works better!

Pick the affirmation that feels most powerful to you, and write it a number of times. On the back of the page write any negative thoughts or feelings that come up. Always finish on the positive side, by writing the affirmation.

My Relationship With Another (or Others)

My current goals in this area are:
(In the form of affirmations — write one, two, or three.)

1.

2.

3.

My ideal scene is:

My Relationship With Another (or Others)
Clearing Process

The reasons I can't have the kind of relationship(s) I want are:

(Tear out and throw away when you've finished, if you want.)

My Relationship With Another (or Others)
Treasure Map

My Relationship with Another (or Others)
Writing My Affirmation

Pick the affirmation that feels most powerful to you, and write it a number of times. On the back of the page write any negative thoughts or feelings that come up. Always finish on the positive side, by writing the affirmation.

My current goals in this area are:
(In the form of affirmations)

1.

2.

3.

My ideal scene is:

The reasons I can't have what I want are:

(Feel free to tear this page out and throw it away once you feel you've gotten all possible negative feelings and thoughts written down.)

Work, Creativity, Financial Prosperity
Treasure Map

Work, Creativity, Financial Prosperity
Writing My Affirmation

Pick the affirmation that feels most powerful to you, and write it a number of times. On the back of the page write any negative thoughts or feelings that come up. Always finish on the positive side, by writing the affirmation.

My current goals in this area are:
(In the form of affirmations)

1.

2.

3.

My ideal scene is:

The reasons I can't have what I want are:

(Feel free to tear this page out and throw it away once you feel you've gotten all possible negative feelings and thoughts written down.)

Health and Appearance

My current goals in this area are:
(In the form of affirmations)

1.

2.

3.

My ideal scene is:

The reasons I can't have what I want are:

Health and Appearance
Treasure Map

Recreation and Travel

My current goals are:

1.

2.

3.

My ideal scene is:

The reasons I can't have what I want:

Recreation and Travel
Treasure Map

The World Around Me

My most important goals in this area are:
(Write them in the form of affirmations.)

1.

2.

3.

My ideal scene is:

The reasons why the world can't be transformed in this way are:

The World Around Me
Treasure Map

Section Five

Inspiration

Some Special Techniques

This section starts with five "positive energy" lists. Start by writing down at least a few items on each of them. Then, every time you use this workbook, start by reading each list and adding another item (or a few) to each of them.

The purpose of these lists is to help you tune in to and appreciate yourself and your life. It gets your positive energy flowing, and automatically helps you open up to your creativity.

The other lists in this section are to be used whenever you want to, or whenever it's appropriate. For example, the pages for recording your dreams can be used every morning when you wake up, or occasionally, when you remember a particularly important dream.

Self-Esteem List

Make a list of the things you like about yourself, no matter how small or large — what you consider to be your positive qualities. Everyone has many positive qualities, and often we don't take time to acknowledge or appreciate ourselves. The better you feel about yourself and the more you appreciate yourself, the happier and more loving you will be, the more your creative energy will flow, and the greater contribution you can make to the world.

Think about things you like about your body, your personality, your character, ways you relate to people, your intellect, your spiritual nature.

Write down everything, even if you feel silly doing it. This is a very important exercise. Keep adding to this list all the time.

For example:

1. *My eyes are beautiful*
2. *I'm very honest and straight-forward*
3. *My sensitivity*
4. *My good memory*
5. *I'm a good friend to others*
6. *I like my legs and feet*
7. *I'm a very enthusiastic person*
Etc.

Things that I like about myself are:

1.

2.

3.

4.

5.

6.

7.

8.

9.

10.

(Continue numbering on your own.)

Make a list of everything you feel you are a success at, or have been a success at, or have done successfully at some time in your life — small things and big things. Include all areas of your life, not just work. Write down everything that has meaning for you, even if it might not to someone else.

The purpose of this list is to acknowledge yourself and your abilities, which increases your energy for creating and accomplishing more.

Keep adding to this list all the time with things that you have accomplished successfully each day.

For example:

1. *I'm a good cook*
2. *I created a successful carpet-cleaning business*
3. *I learned to speak Italian*
4. *I choreographed and directed a dance performance for 20 kids*
5. *When I was 8, I learned to ride my bicycle*
6. *When I was 16, I got my first job delivering groceries*
7. *I successfully completed my electronics course*
8. *I built the shelves in my house*
9. *Today I was able to express my feelings clearly and directly with my roommate*
Etc.

Things that I have done successfully are:

1.

2.

3.

4.

5.

6.

7.

8.

9.

10.

(Continue numbering on your own.)

Appreciation List

Make a list of everything that you can think of that you are especially thankful for, or that you especially appreciate having in your life. Making and adding to this list can really open up your heart, and your awareness of the many riches we all have already created in our lives that we often take for granted. It increases your realization of prosperity and abundance on every level, and thus your ability to manifest.

For example:

1. *My friends*
2. *My children*
3. *The beauty of nature – especially my moments at the beach and on the hill near my house*
4. *The opportunity I've had to grow and get conscious*
5. *Rock and roll music, and going dancing*
Etc.

The things that I am thankful for, and appreciate in my life are:

1.

2.

3.

4.

5.

6.

7.

8.

9.

10.

11.

12.

(Continue numbering on your own.)

Self-Appreciation List

Write down all the ways you can think of to be good to yourself, nice things that you can do for yourself, things that are just for your own pleasure and satisfaction. They can be small or large, but make some of them be things that you can do every day, and then do them! This increases your sense of well-being and satisfaction, which helps you to come from a clearer space in creating your life. Add to this list as you think of new things.

For example:

1. *Soak in a hot bath*
2. *Go out dancing!*
3. *Take a few minutes to relax and be quiet every day*
4. *Get a massage*
5. *Eat something really delicious and nutritious!*
6. *Buy myself a new scarf*
7. *Buy myself a new typewriter*
8. *Spend some time just hanging out with Michael*
Etc.

Some nice things I can do to appreciate myself are:

1.

2.

3.

4.

5.

6.

7.

8.

9.

10.

11.

(Continue numbering on your own.)

Outflow List

Make a list of all the ways that you can outflow your energy to the world and to others around you, both generally and specifically. Include ways that you outflow money, time, love and affection, appreciation, physical energy, friendship, touching, and your special talents and abilities. Follow through on actually doing these things as you feel like it. Add to this list when you think of new things.

For example:

1. *Give foot massages*
2. *Call my father*
3. *Show Jim how to use his new camera*
4. *Buy someone lunch*
5. *Express more verbal appreciation to my friends and family*
6. *Take my photographs to some galleries*
7. *Cook dinner for the family*
Etc.

Some ways that I can outflow my energy to the world and/or to other people are:

1.

2.

3.

4.

5.

6.

7.

8.

9.

10.

11.

12.

(Continue numbering on your own.)

Healing and Assistance List

Write down the names of any people you know who need healing or special support or assistance of any sort. Then write down an affirmation (a positive statement in the present tense) describing the desired reality you would like to help them create. Then every time you look through your notebook you'll be giving them a positive "boost" of your energy. What they do with that energy is up to them. You can't influence or control them, only support them in what *they* feel is best for them.

Example:

Name: John Jones
Affirmation: John Jones is now working at a job that he loves, and getting paid well for it.

Name: Elsie Miller
Affirmation: Elsie is feeling well and radiantly healthy.

Name: Karen Smith
Affirmation: Karen is feeling peaceful and relaxed inside. She is loving herself more every day.

Some people whom I would like to love and support in special ways are:

Name:
Affirmation:

Name:
Affirmation:

Name:
Affirmation:

Name:
Affirmation:

Name:
Affirmation:

Name:
Affirmation:

Creative Ideas and Thoughts

This is a special area for you to jot down any creative ideas, fantasies, or thoughts that come to you at any time. These do not need to be complete, or even make much sense. This is just a way to take a look at little flashes and inspirations that may come from your intuitive mind. Don't take it seriously, and don't worry if you don't feel like you have anything to write on this page.

Some examples:

5/15 *When I was relaxing today, I suddenly started thinking that I'd like to go into business for myself. I saw myself in a beautiful office, with a secretary, and a lot of plants and lovely furniture. I had the feeling that I was doing some type of consulting work.*

6/3 *I had the idea that I'd like to start taking singing lessons!*

6/8 *In meditation I saw a large bird, like an eagle, and he was bringing a gift to me in his beak. I felt like the universe was blessing me.*

Creative Ideas and Thoughts
(continued)

Recording Your Dreams

Since our dreams are a powerful key to our intuitive mind, it can be fun and very meaningful to practice writing down your dreams.

Before you go to sleep at night, say to yourself, "I will wake up and remember clearly at least one dream." Then if you wake up during the night, or in the morning, immediately check to see if you can remember any dream or fragment of a dream. Start writing it down immediately, and often more details and understanding will come as you do so. Then write down what you think the dream may mean, what your intuitive mind may be trying to communicate to you.

Recording Your Dreams
(continued)

Inspiring Quotes

Use this space to write down any especially inspiring or helpful phrases from books, poems or songs that you like. If you want to, take this workbook with you if you go to hear speakers or teachers, and jot down any special ideas that you want to remember.

Inspiring Quotes
(continued)

Favorite Affirmations

As you work with creating affirmations, keep track of the ones you especially like, or have found especially powerful for you, by writing them on this list. Or if you find certain affirmations you like in *Creative Visualization* or other books, write them down here.

Workbook Record

You can use this page to record how often you work in your workbook, and what you do each time. For fun, you can give yourself a gold star each time if you want to.

Date *What I did in my workbook today:* *Gold Star*

Other Books and Tapes
From Whatever Publishing

BOOKS

Creative Visualization by Shakti Gawain. This clear and practical guide contains easy-to-use techniques to: feel more relaxed and peaceful, increase your vitality and improve your health, develop your creative talents, create more fulfillment in relationships, reach your career goals, dissolve negative habit patterns, increase your prosperity, and much, much more.

Living in the Light by Shakti Gawain with Laurel King. Shows us a new way of life — becoming a channel for the creative power of the Universe by developing our intuition. Offers both practical and inspirational guidance in expanding our perspective on who we are and what we have the potential to become.

Anybody Can Write by Jean Bryant. Functions as a personalized, self-guided writing workshop that will inspire anyone who is fascinated by the magical power of words on paper. A delightful approach for the non-writer, "blocked" writer and the beginner.

Friends and Lovers—How to Create the Relationships You Want by Marc Allen. An upbeat, knowledgeable, and contemporary guide to living and working with people. Contains a six-step process that is *guaranteed to settle arguments* at home or at work.

Work With Passion—How To Do What You Love For A Living by Nancy Anderson. This highly effective guide will help you master the secrets of finding your niche in life — doing what you love to do and getting paid well for it. *Work With Passion* is filled with inspiring stories of ordinary people who have achieved extraordinary results by following the nine-step program of the author, developed during her years as a highly successful career consultant. This is *the* career book of the 1980's!

Tantra for the West—A Guide to Personal Freedom by Marc Allen. Practical and informative, *Tantra for the West* presents proven principles and techniques to improve the quality of your life in all areas: relationships, sex, work, money, being alone, creativity, food and drink, meditation and yoga, aging and healing, politics, enlightenment and freedom. "A clear and timely book ..."—Marilyn Ferguson.

CASSETTES

Living in the Light. In this powerful hour-long interview, Shakti Gawain reveals the main principles and techniques from her book of the same title, showing us how to connect with our intuition and become a creative channel for personal and planetary transformation.

Stress Reduction and Creative Meditations. Marc Allen guides you through a deeply relaxing, stress-reducing experience on the first side. Side Two contains effective, creative meditations for health, abundance, and fulfilling relationships. Soothing background music by Jon Bernoff.

Creative Visualization. Shakti Gawain guides you through some of the most powerful and effective meditations and techniques from her book.

ORDERING INFORMATION

We invite you to send for a free copy of our full-color catalogue so that you can see our complete selection of books and cassettes.

Whatever Publishing, Inc.
P.O. Box 13257, Northgate Station
San Rafael, CA 94913
(415) 472-2100

ORDER TOLL FREE WITH YOUR VISA/MC

(800) 227-3900
(800) 632-2122 in California

WORKSHOPS: For information about Shakti Gawain's workshops, write to or call:

SHAKTI CENTER
P.O. Box 377
Mill Valley, CA 94942
(415) 927-2277